Monet.

at
GIVERNY

A
Book
of Days

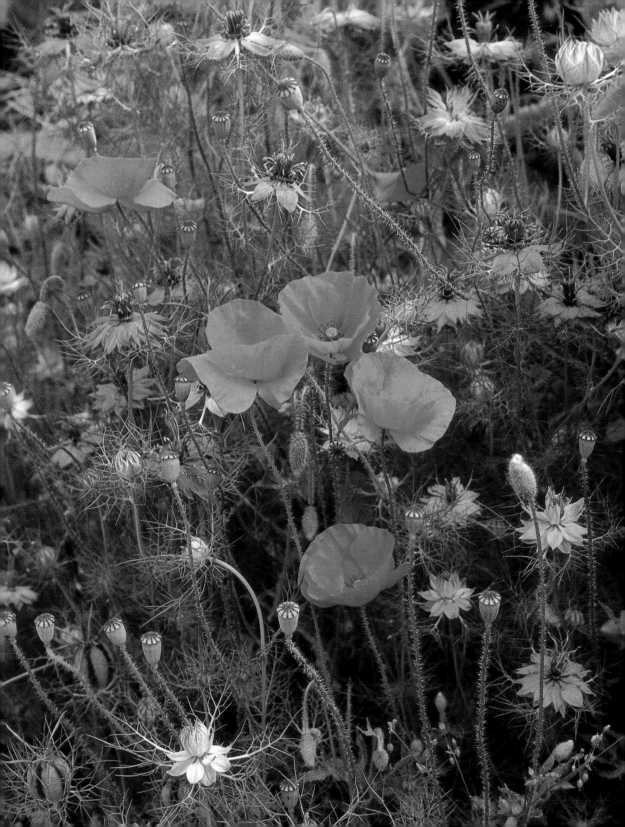

Monet.
at
GIVERNY

A
Book
of Days

with photographs by
Derek Harris

Little, Brown and Company
Bulfinch Press
Boston New York Toronto London

First United States edition
Sixth printing, 1993
ISBN 0-8212-1737-2
Library of Congress Catalog Card Number 88-63016
First published in Great Britain in 1989 by Ebury Press Stationery

Cover illustration: Les Coquelicots. Le Musée d'Orsay, Paris.
Introduction illustration: Le Déjeuner. Le Musée d'Orsay,
Paris.

The publishers would like to thank all the photographers for
their help in photographing the paintings.
Lauros/Giraudon
G. Dagli Orti
Hubert Josse
Jean-Michel Routhier
W. Drayer
Fotostudio Otto
Bridgeman Art Library

Bulfinch Press is a trademark of Little, Brown and Company (Inc.)
PRINTED IN SINGAPORE

Introduction

Claude Monet first came to the tiny village of Giverny in 1883. Some 50 kilometres north-west of Paris, it was ideally situated – in the country and landscape he loved and close enough to Paris for the art dealers, the artists and friends who were to visit him.

After having to move from Poissy, which he hated, and having to find somewhere to live, Monet was irresistibly drawn to the Seine valley. He had previously lived at Vétheuil and remembered the pleasant walks and the boat trips down the Seine and into the district of Vernon where he had found inspiration.

By travelling and making several explorations on the local, slow and meandering railway trains, he finally 'found' Giverny situated between gently undulating hills, the river Epte and the nearby Seine, an area of interesting and changing light.

At first the house was rented – it was a time when Monet's work was misunderstood and it was a time of extreme hardship with dire financial difficulties for Monet and his large family. It was with the financial help and support of the art dealer Paul Durand-Ruel, who nearly ruined his business by supporting the impressionists, that Monet was able to pay the rent and survive at this time.

For the previous five years, the families of Monet and Ernest Hoschedé – who had fled after bankruptcy and left his wife Alice and their six children – shared and lived together. Monet's wife Camille and Alice, as well as the children, shared clothing and they had gone to being nearly destitute.

It was the great personal strength and belief that Alice had in Monet's genius that held the families together. Tragically Monet's wife died in 1879 and a desperate and lost Monet had left the care of his two sons to Alice, a dignified and sensitive woman. Nevertheless, even with the great financial difficulties and problems of moving his family, paintings and posses-sions he soon knew that he was at home. 'I am filled with delight, Giverny is a splendid spot for me. …', he wrote just one month after moving there.

It was not long before Monet and Alice, who married in 1892, set about planning and creating what was to become one of Monet's masterpieces. The original garden was stiff, unimaginative, typically provincial, bourgeois and without any interest. It was soon being transformed as Monet was anxious for the kitchen and flower garden to be planted. From the first plans they included flowers for painting and flowers for cutting so that the Artist had subjects for bad and wet days when he would have to be in his studio. He loved the garden and would rise early, sitting for hours studying the changing light and colours and the play of light on water, which led him to the Eastern tradition of the philosophical contemplation of nature. This became an important part of his work and creation.

Over the next years the garden developed and as Monet became more famous, his work began to sell and he was eventually able to buy the house and garden with an additional plot of land beyond the garden, known as the Clos Normand. The additional plot, after many problems, in 1895 was turned into the now famous water garden with its water lilies and Japanese Bridge, an area which inspired much of Monet's greatest work.

With the purchase of the house and gardens, Monet, with the help of six gardeners, was able to carry out major alterations and construction which was to make the house and gardens much as we see them today. The gardens, created over several decades, should be considered as a work of art. Conceived by a painter with a love and passion for nature, these gardens have inspired the famous expression 'A painting executed on nature itself'.

The garden at Giverny became a recurring theme before becoming his only subject towards the end of his life. With his own garden studio, he was able to study the subtle effects of the

ever changing light, times of day and seasons of the year.

There can be no doubt of the roles that Monet and, through Monet, the gardens of Giverny have played in the art of the twentieth century. Most of the famous and not so famous artists of the day visited Monet at Giverny and his greatest works inspired by the light, colour and water of Giverny have influenced the world of modern art.

Claude Monet spent 43 years at Giverny and created a beautiful, living garden. He died in 1926. The house was maintained by his daughter-in-law Blanche until her death in the 1940s, when the house and garden were allowed to fall into serious neglect and decay. The property and remaining paintings were left to the Académie Des Beaux-Arts, who in 1977 appointed Gerald van der Kemp, the successful Curator of Versailles, as Curator of Giverny and the person responsible for returning the house and gardens to their original condition.

The greatest compliment is to say that the house and gardens have indeed been returned to their former glory and are now as Monet left them. The considerable effort and work is rewarded by the most beautiful and inspiring gardens, an ever-changing kaleidoscope of flowers, colours and wonderful impressions. The gardens change dramatically with the seasons, each short season bringing striking contrasts and brilliant colours which are distinctly different from the one before.

It is indeed a living museum which is unique in France as the only complete and authentic house and gardens of a world famous artist – they are a joy to visit and an exciting experience to photograph.

Derek Harris

GIVERNY
The House and Gardens are open from 1st April to 31st October.
The Gardens are open from 10 am to 6 pm. The House is
open from 10 am to 12 noon and from 2 pm to 6 pm.
Giverny is closed on Mondays.

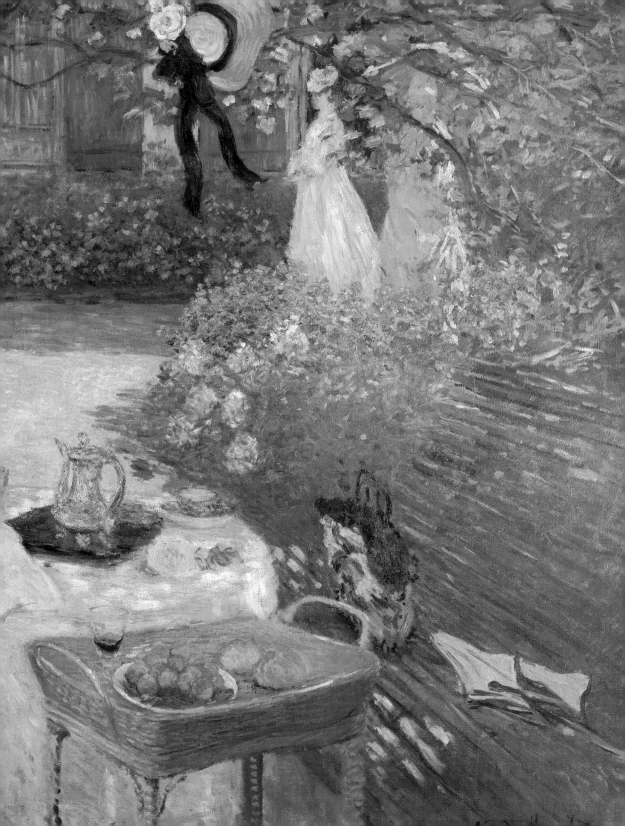

January

1

The water garden.

2

3

4

5

6

7

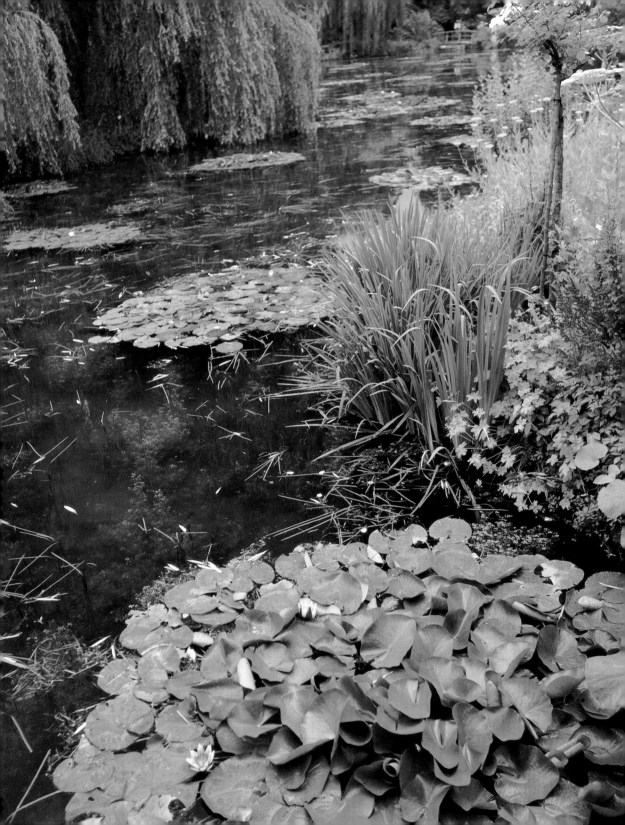

January

8

9

10

11

12

13

14

Les Nymphéas. Reflets verts. L'Orangerie.

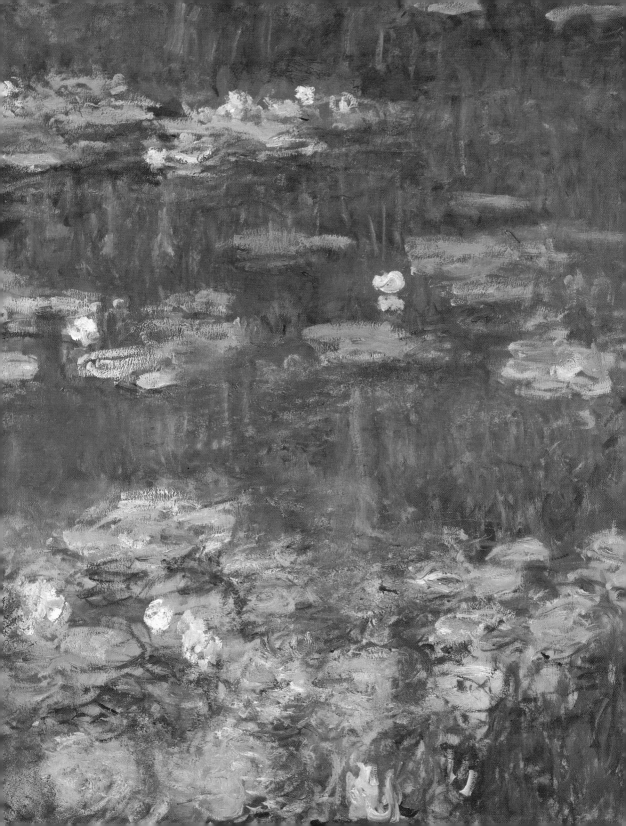

January

15

16

17

18

19

20

21

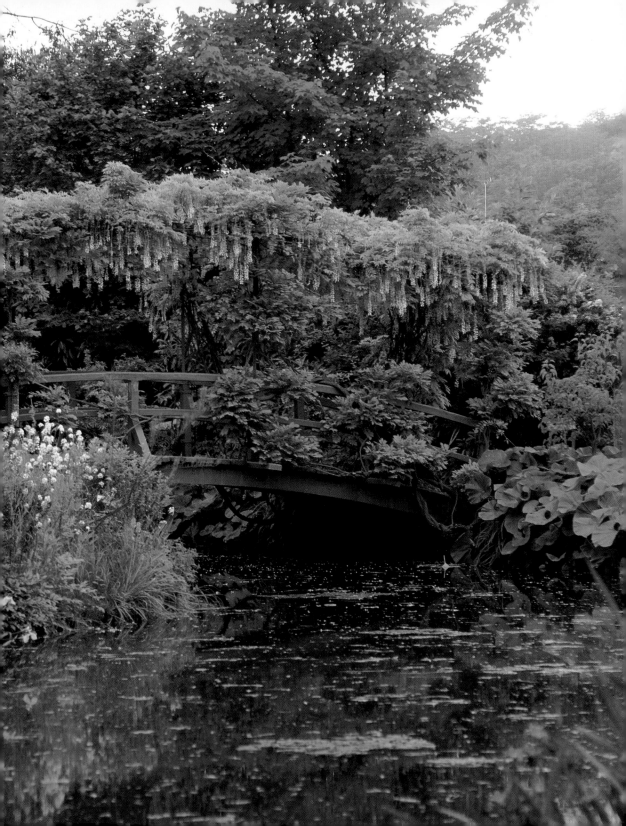

January

———————————— 22 ————————————

———————————— 23 ————————————

———————————— 24 ————————————

———————————— 25 ————————————

———————————— 26 ————————————

———————————— 27 ————————————

———————————— 28 ————————————

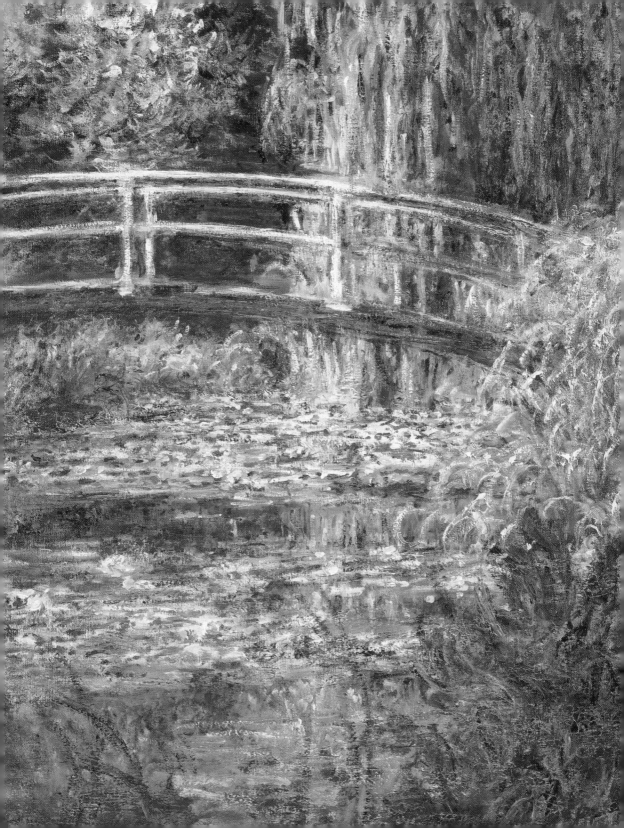

January-February

29

30

31

1

2

3

4

The central pathway to the house, spring.

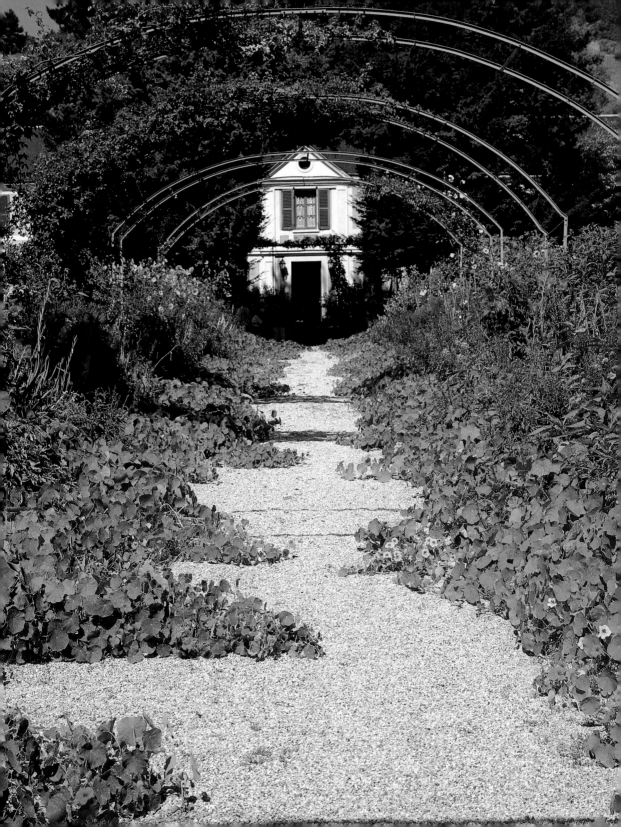

February

5

*Le Jardin à Giverny,
1902. Österreichische
Galerie, Wien.*

6

7

8

9

10

11

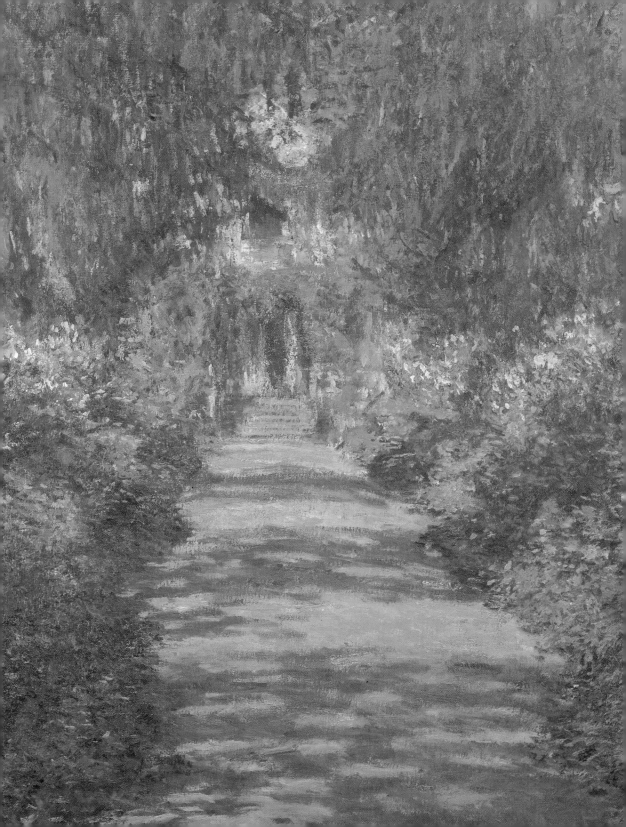

February

12

13

14

15

16

17

18

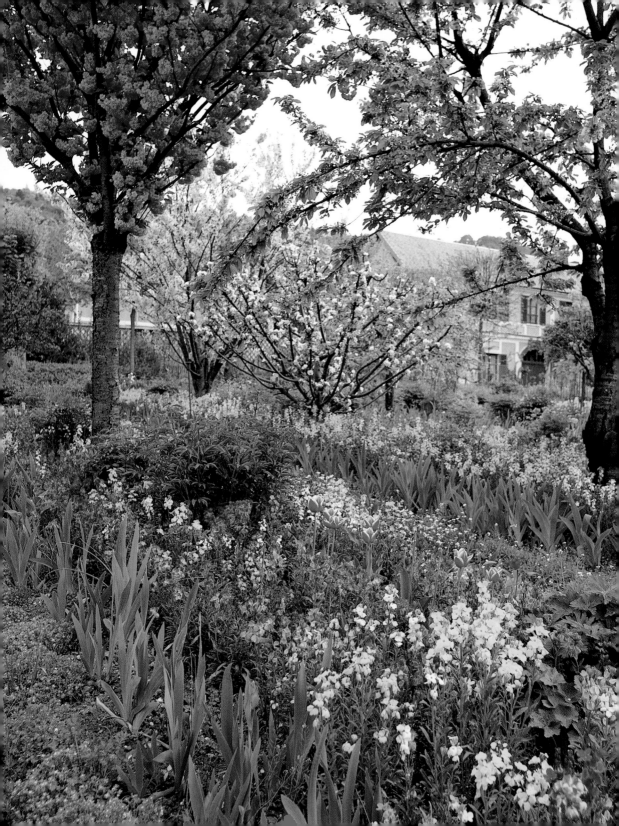

February

19

20

21

22

23

24

25

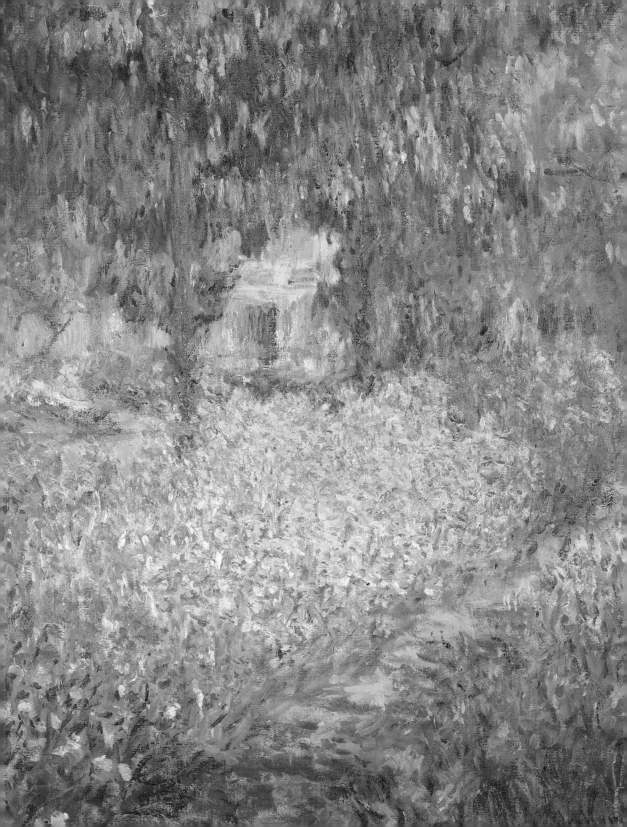

February-March

Spring blossoms in the
'Clos Normand'.

27

28

29

1

2

3

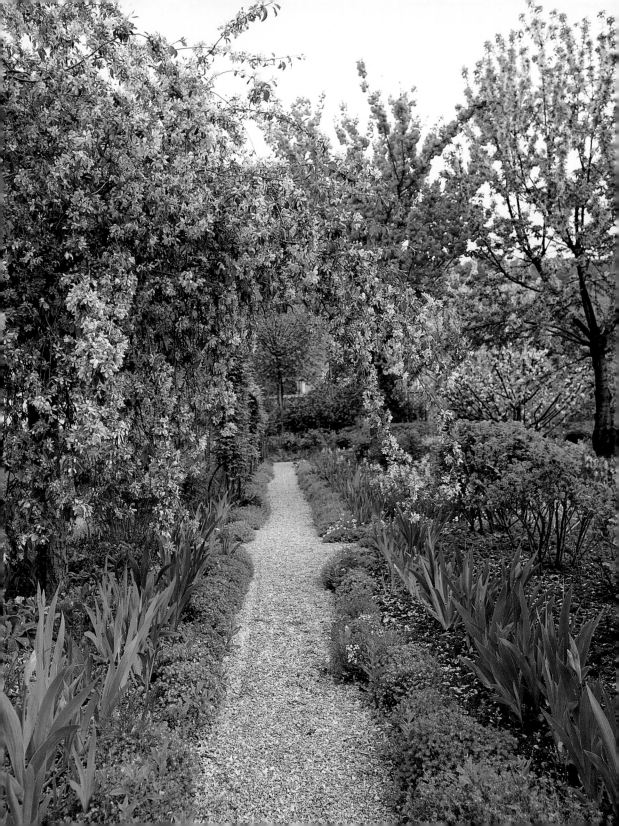

March

4

5

6

7

8

9

10

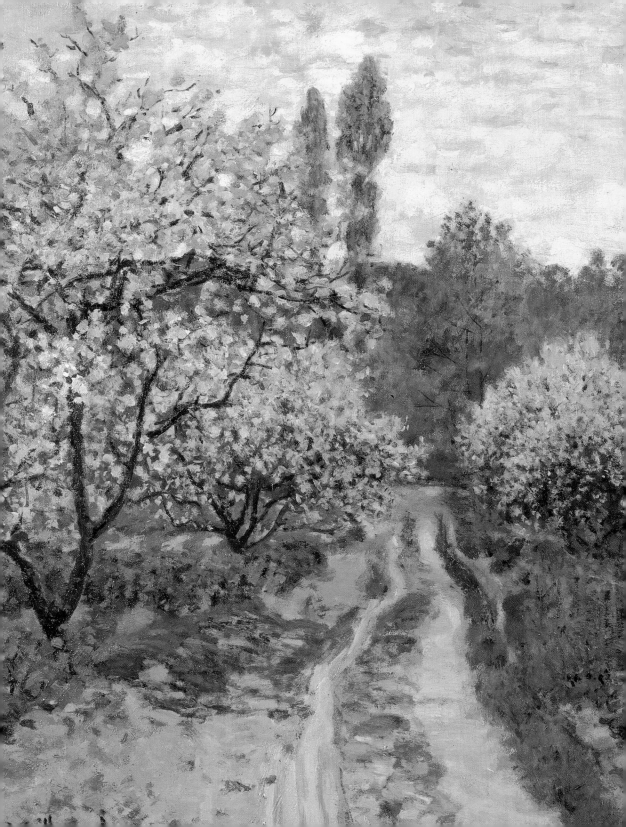

March

11

The artist's house and garden.

12

13

14

15

16

17

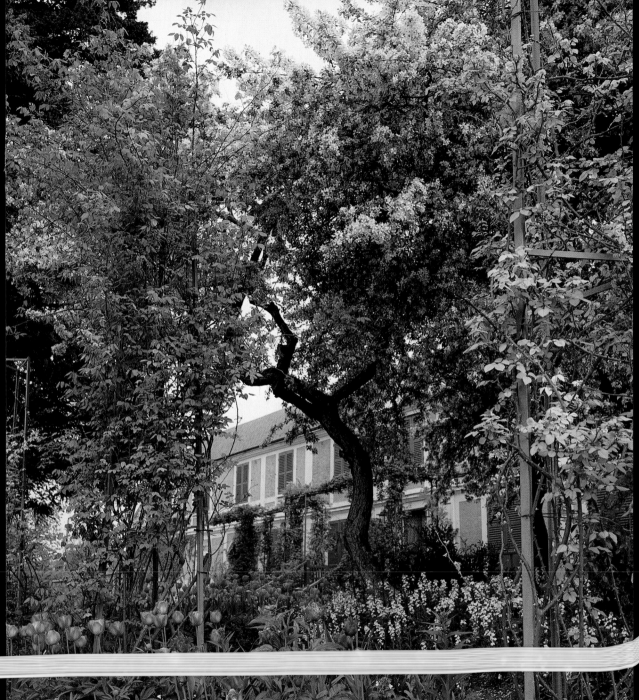
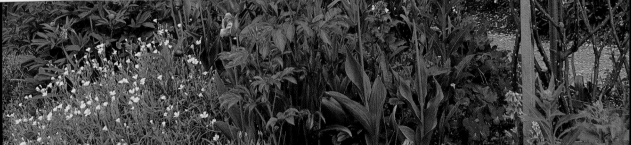

March

18

19

20

21

22

23

24

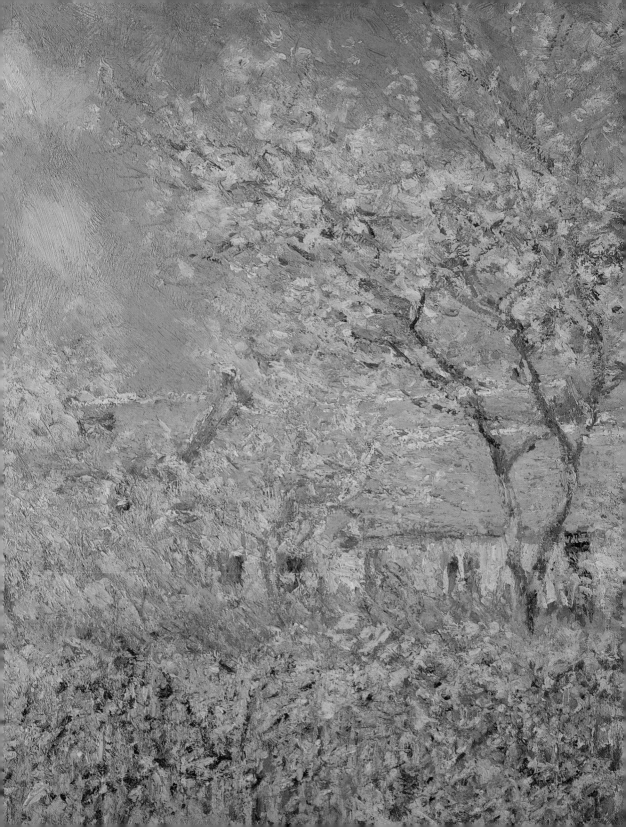

March

25

26

27

28

29

30

31

Irises in the water garden, spring.

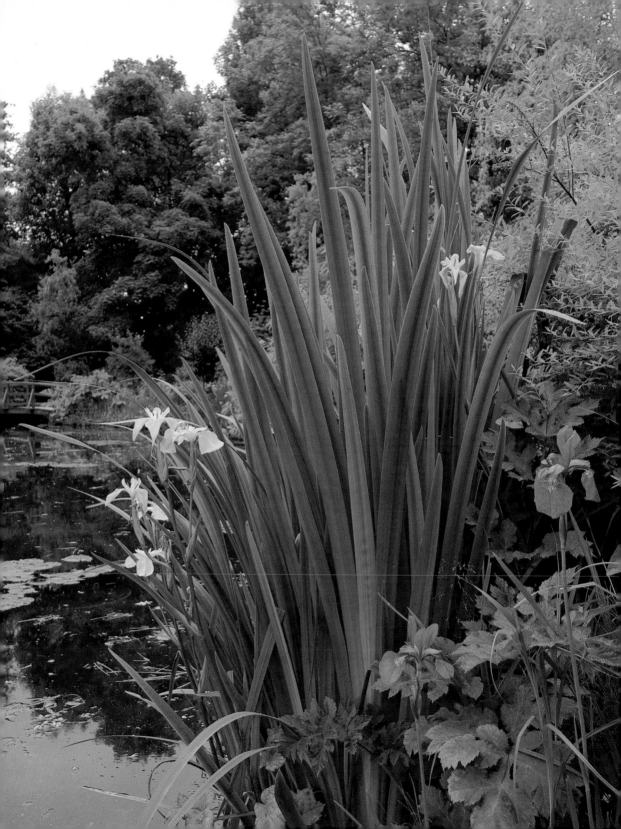

April

1

2

3

4

5

6

7

Iris. Le Musée Marmottan.

April

8 ——————————————————————————— *Water lilies.*

9

10

11

12

13

14

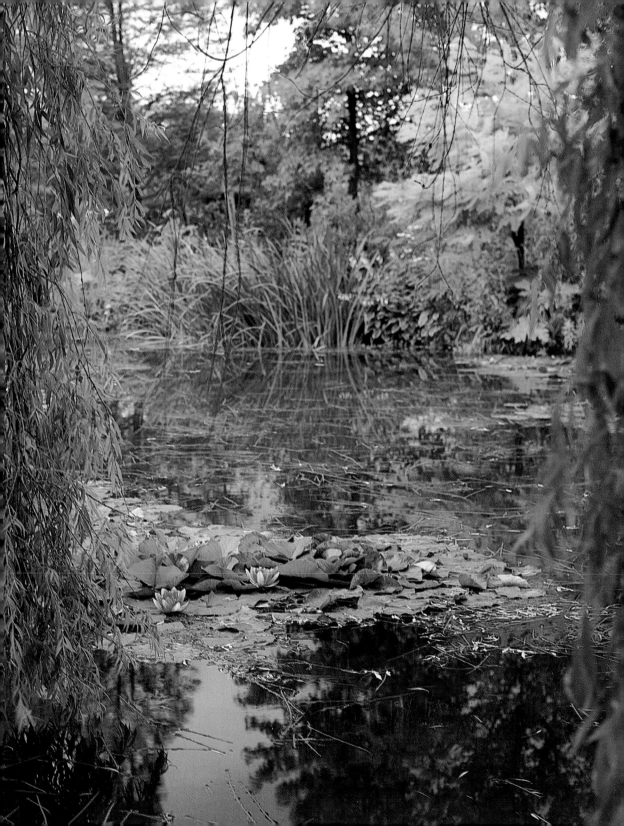

April

— 15 —

— 16 —

— 17 —

— 18 —

— 19 —

— 20 —

— 21 —

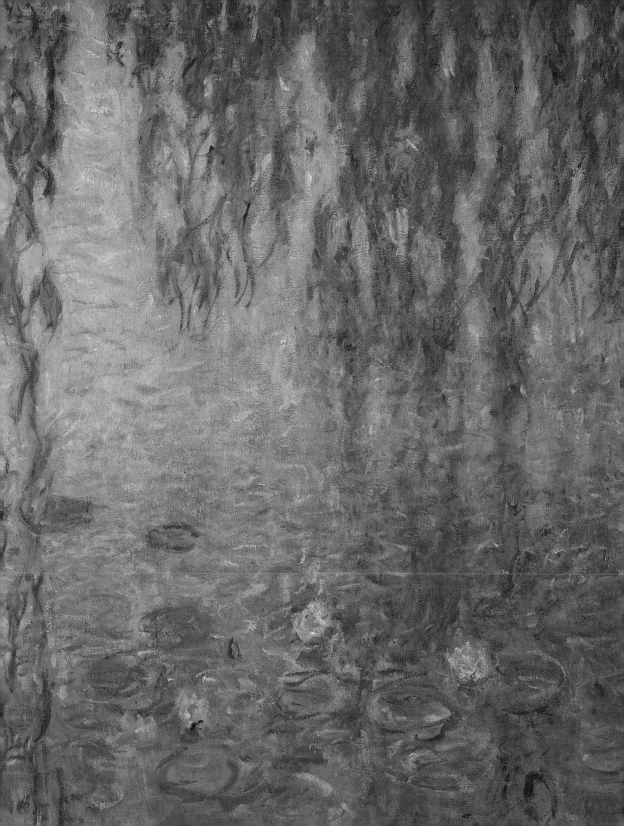

April

22

23

24

25

26

27

28

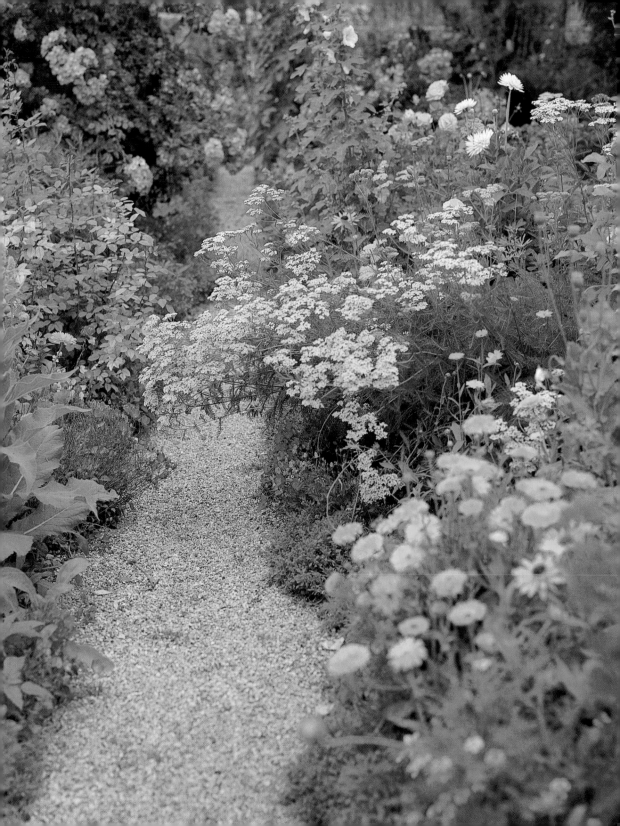

April-May

29

30

1

2

3

4

5

Le Jardin de l'Artiste à Giverny, 1895. Foundation E. G. Bührle.

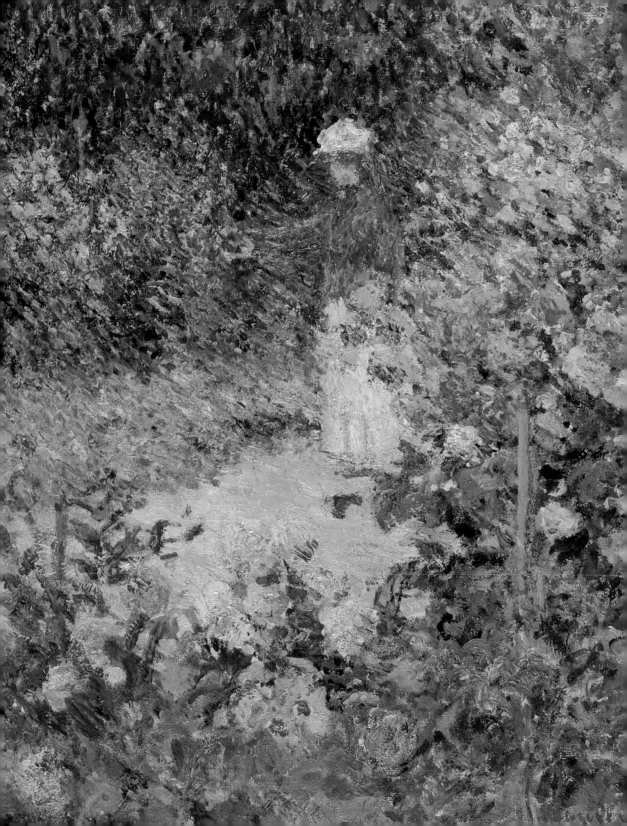

May

6

7

8

9

10

11

12

Boat in the water garden.

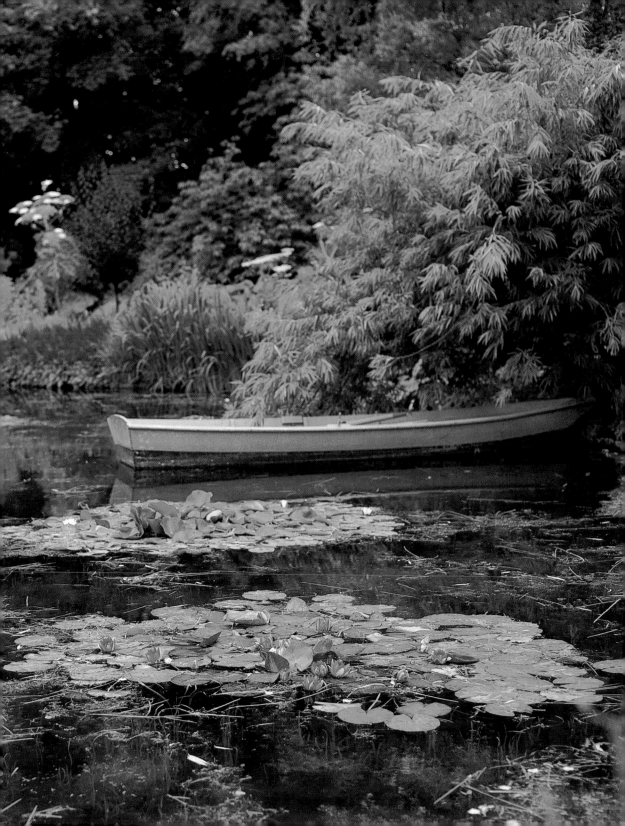

May

_____ 13 _____

_____ 14 _____

_____ 15 _____

_____ 16 _____

_____ 17 _____

_____ 18 _____

_____ 19 _____

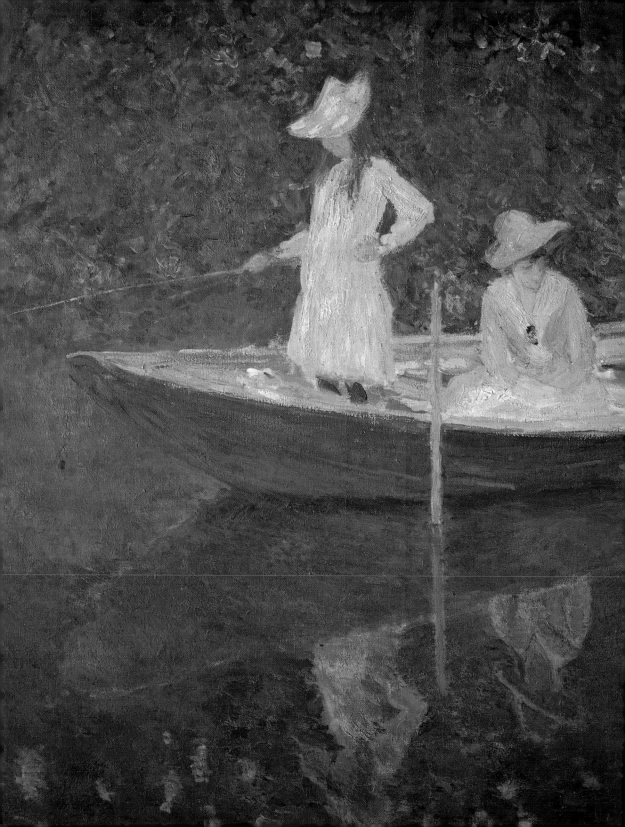

May

20

21

22

23

24

25

26

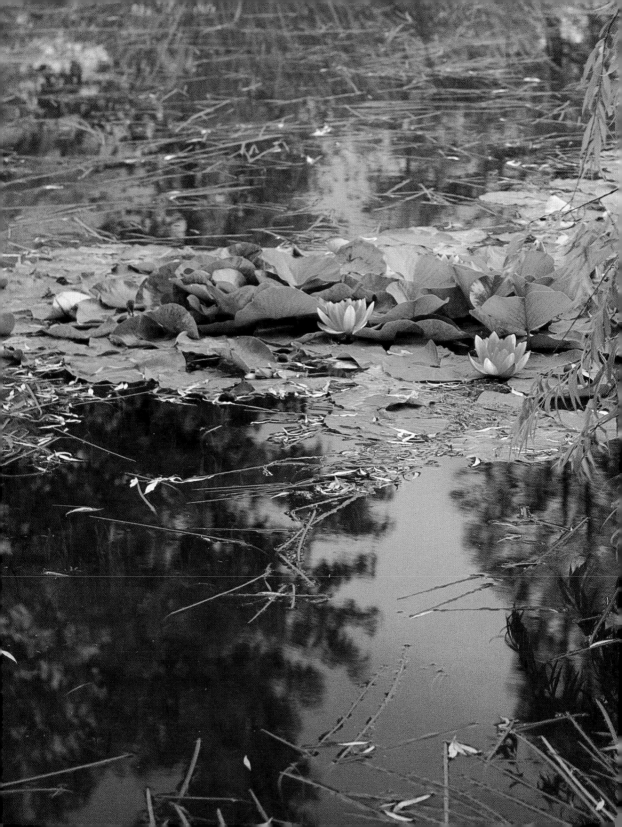

May-June

——————————————— 27 ———————————————

——————————————— 28 ———————————————

——————————————— 29 ———————————————

——————————————— 30 ———————————————

——————————————— 31 ———————————————

——————————————— 1 ———————————————

——————————————— 2 ———————————————

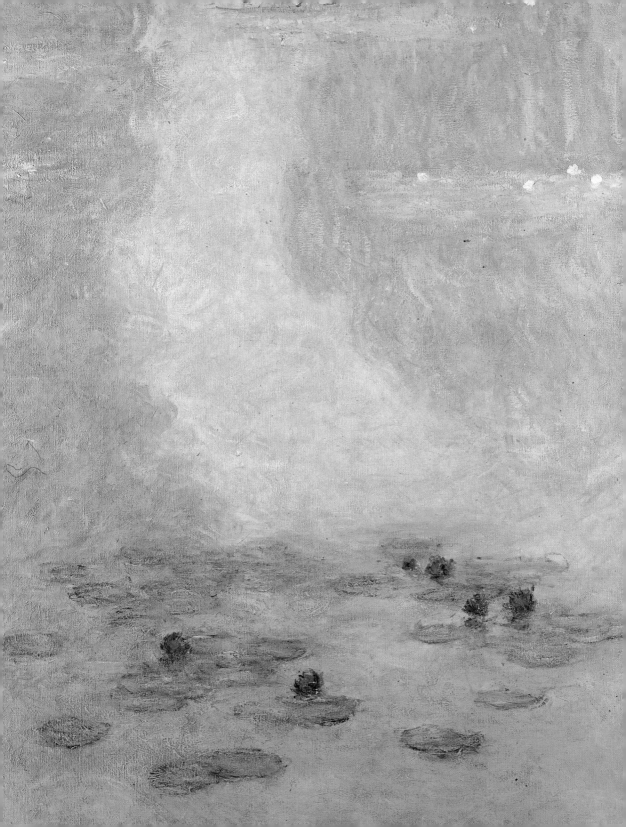

June

3

4

5

6

7

8

9

The artist's house with a mixed bed of tulips and forget-me-nots in the foreground.

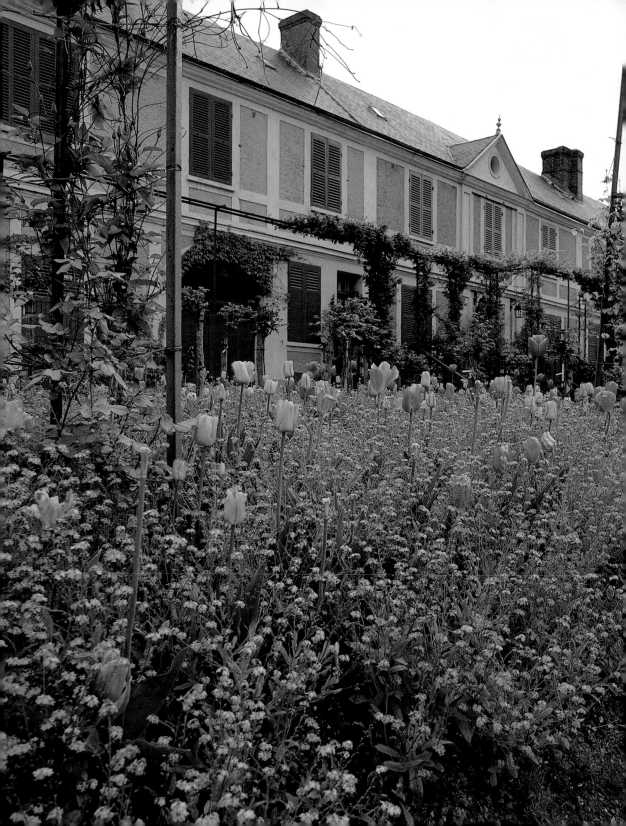

June

10

11

12

13

14

15

16

Jardin en Fleurs, 1866.
Le Musée du Louvre.

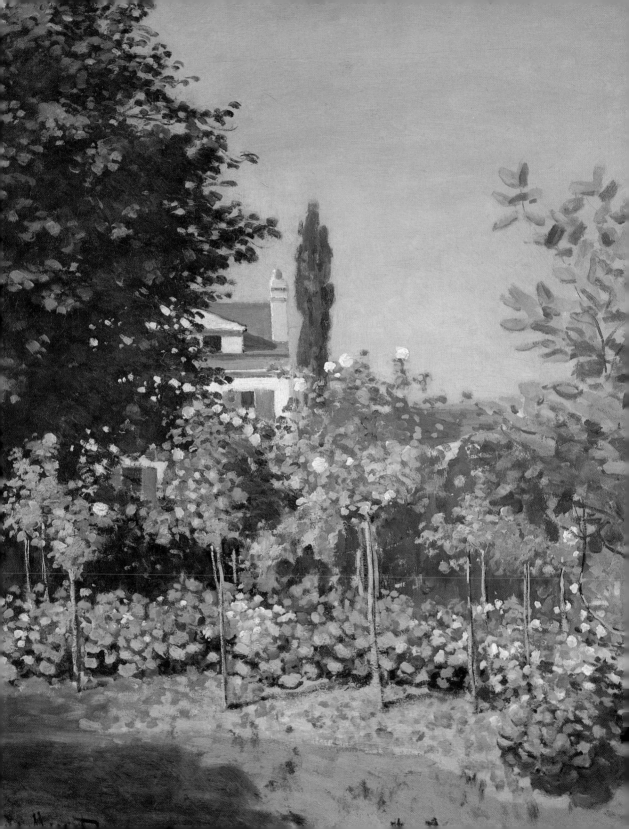

June

17

18

19

20

21

22

23

Climbing roses in the 'Clos Normand'.

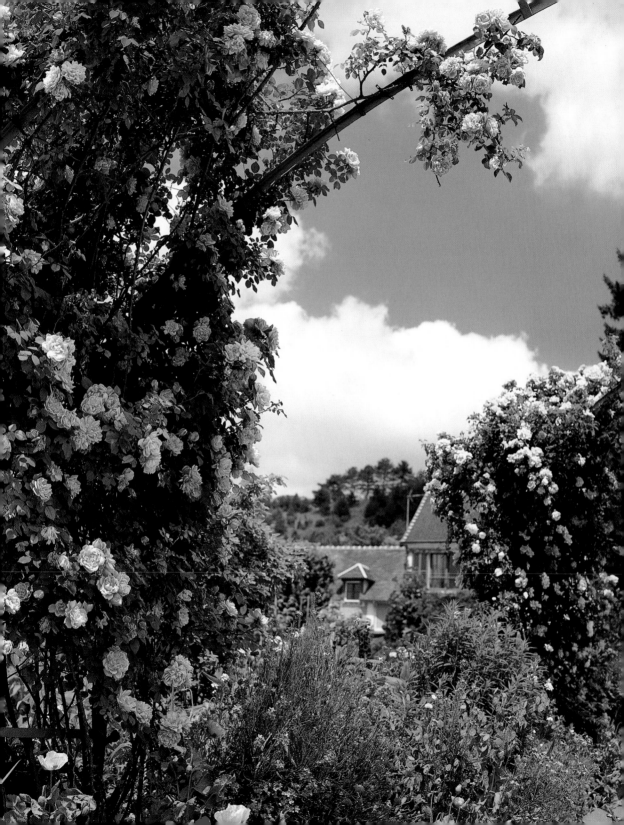

June

24

25

26

27

28

29

30

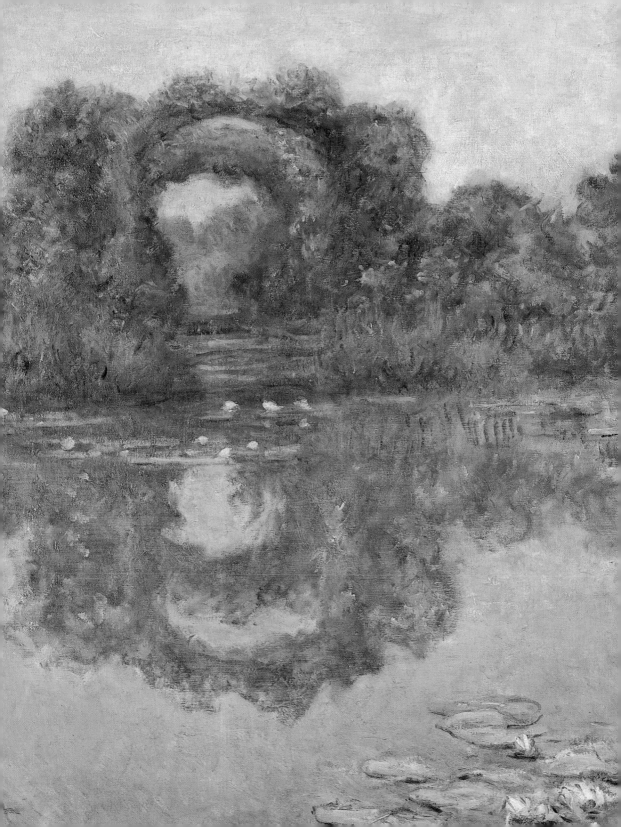

July

1

2

3

4

5

6

7

*Spring blossom in the
'Clos Normand'.*

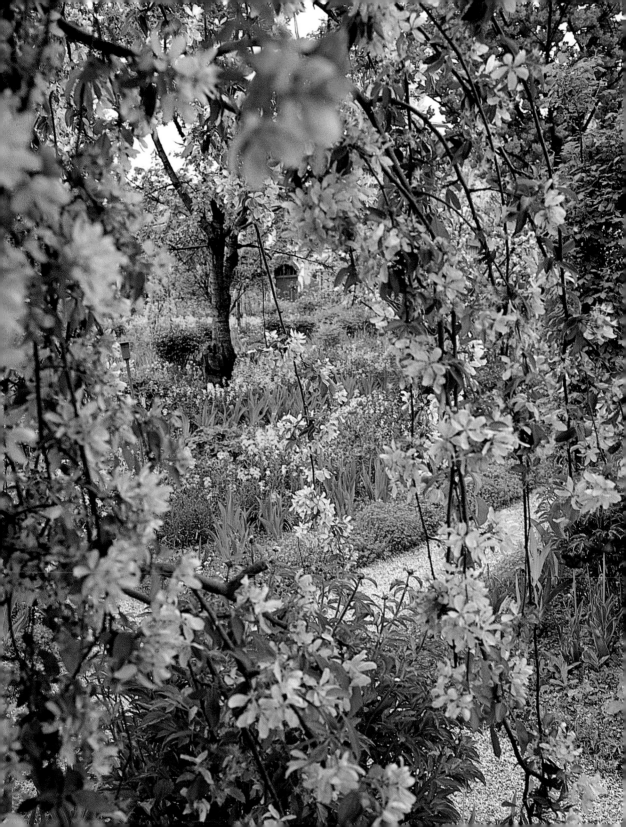

July

8

9

10

11

12

13

14

Le Repos sous les Lilas,
c1873. Le Musée du
Louvre.

July

15

18

17

18

19

20

21

The Japanese bridge with
hanging willows and
water lilies.

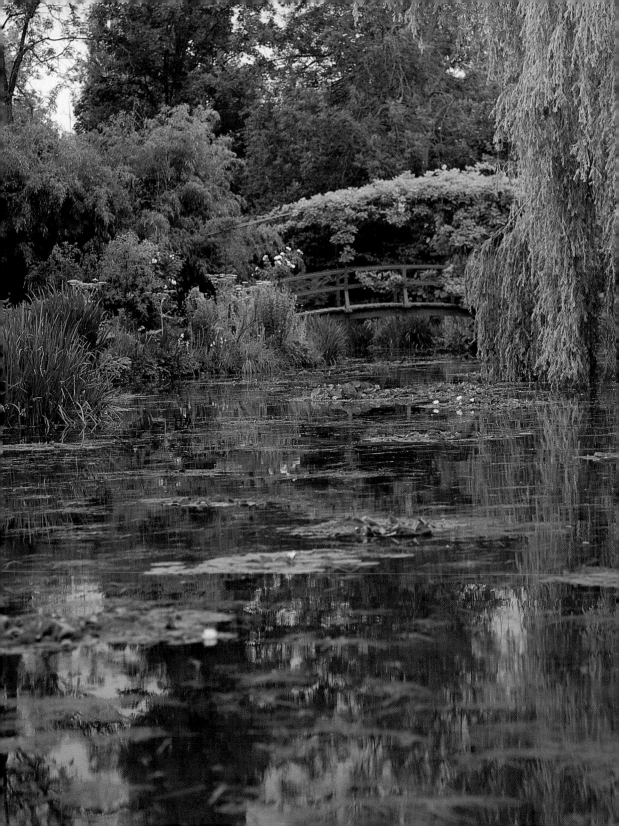

July

22

Les Nymphéas. Le Nouveau Musée, Le Hâvre.

23

24

25

26

27

28

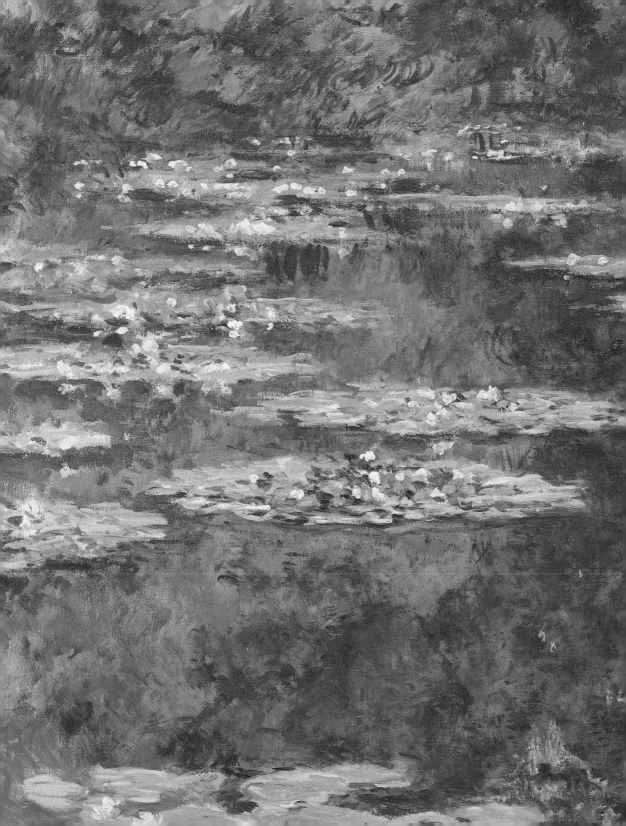

July-August

———————————— 29 ————————————

———————————— 30 ————————————

———————————— 31 ————————————

———————————— 1 ————————————

———————————— 2 ————————————

———————————— 3 ————————————

———————————— 4 ————————————

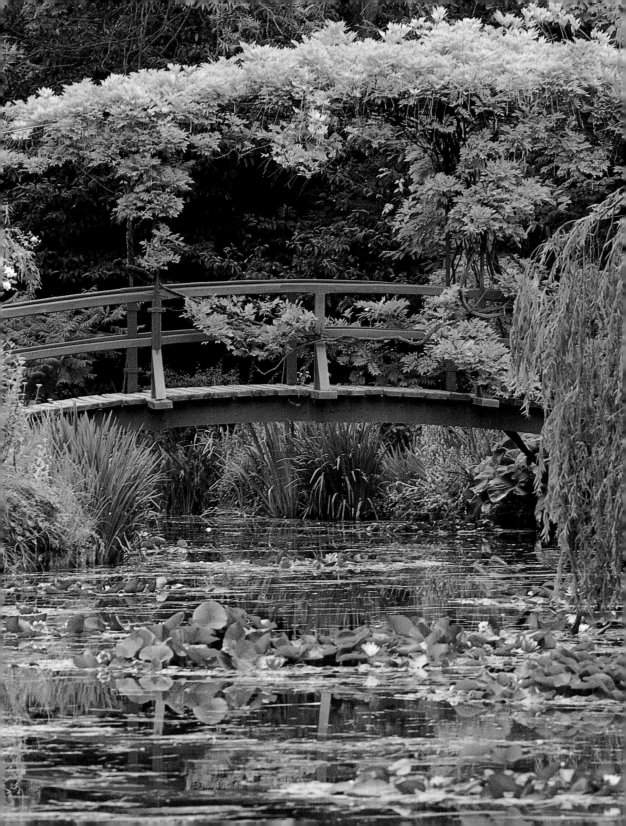

August

5

6

7

8

9

10

11

Le Bassin aux Nymphéas. The National Gallery.

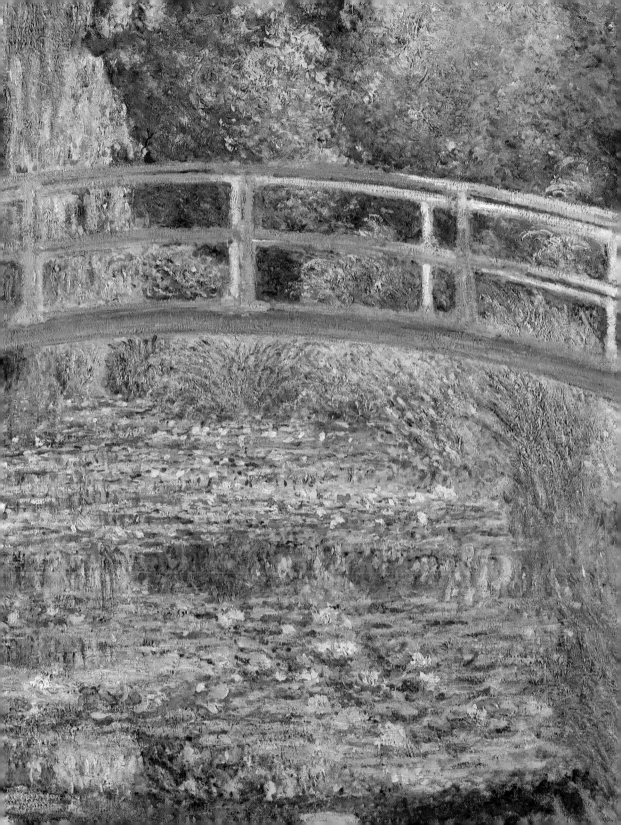

August

12

13

14

15

16

17

18

*The 'Clos Normand',
summer.*

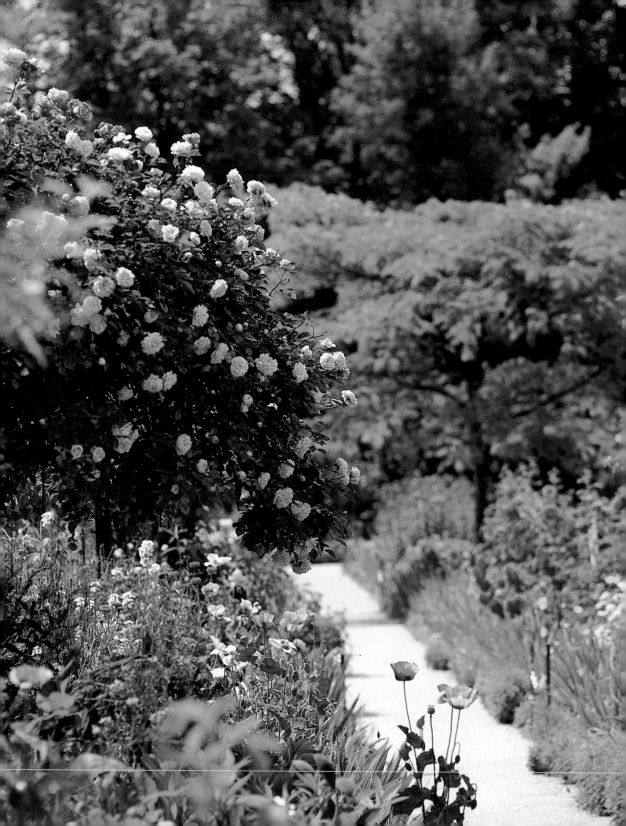

August

19

20

21

22

23

24

25

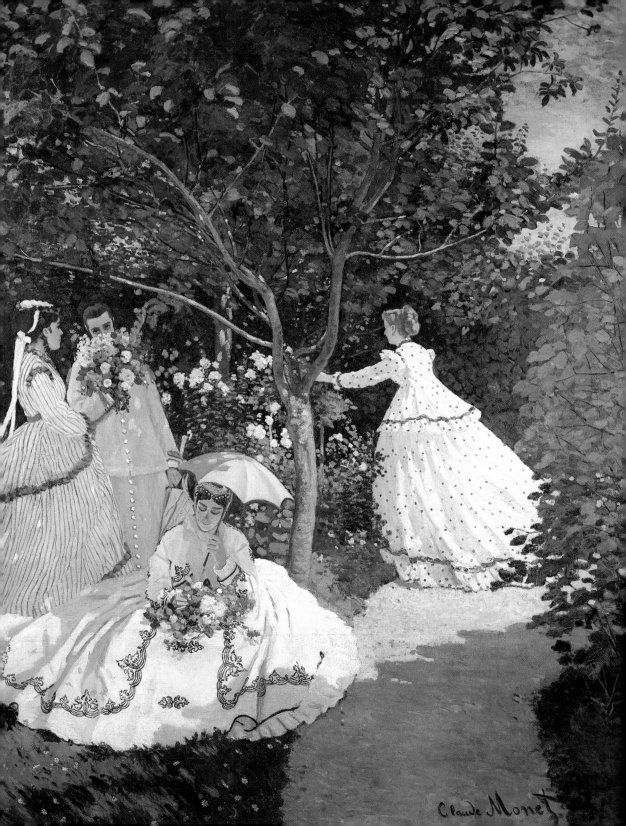

Claude Monet

August-September

—————————— 26 —————————— *Water lilies.*

—————————— 27 ——————————

—————————— 28 ——————————

—————————— 29 ——————————

—————————— 30 ——————————

—————————— 31 ——————————

—————————— 1 ——————————

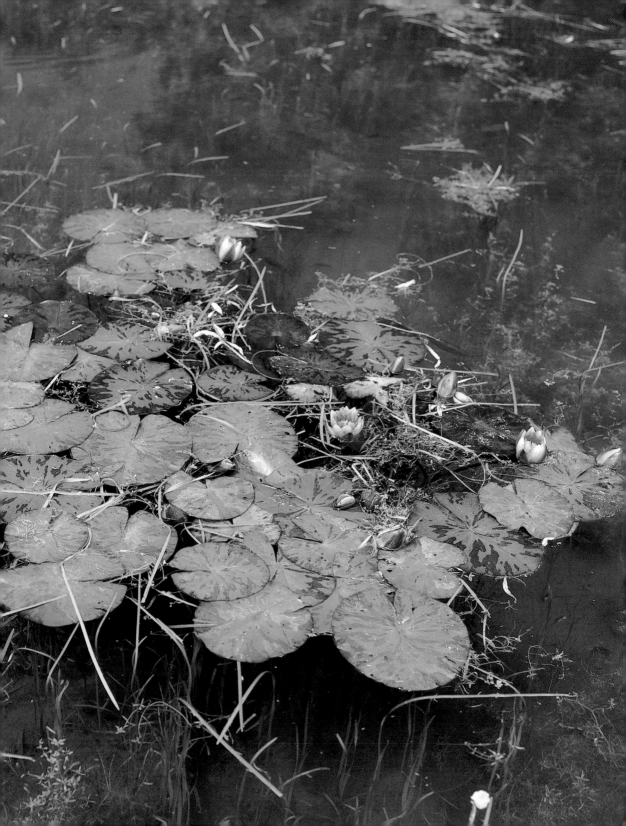

September

2

3

4

5

6

7

8

Les Nymphéas, 1920–1. The Carnegie Museum of Art, Pittsburgh. Acquired through the generosity of Mrs Alan M. Scaife, 1962.

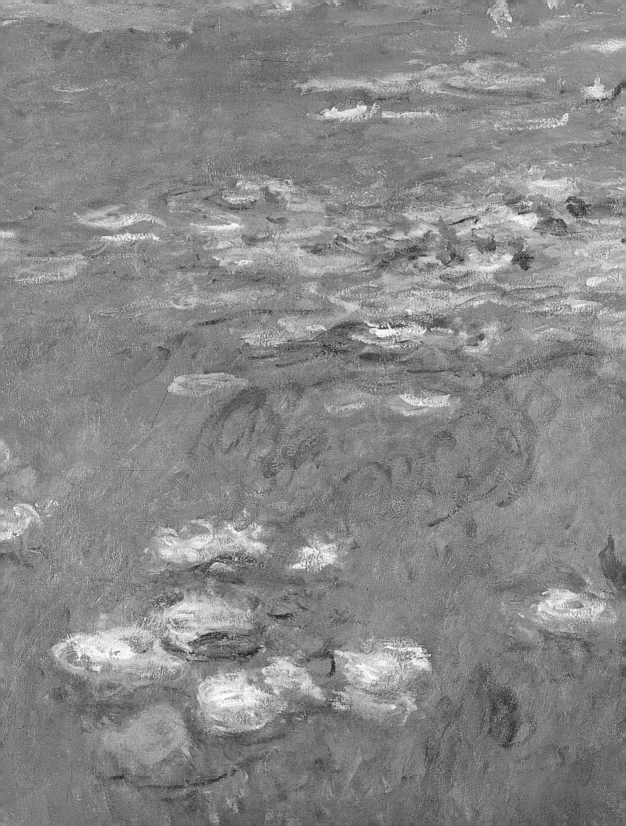

September

9

10

11

12

13

14

15

Red tulips in the water garden, spring.

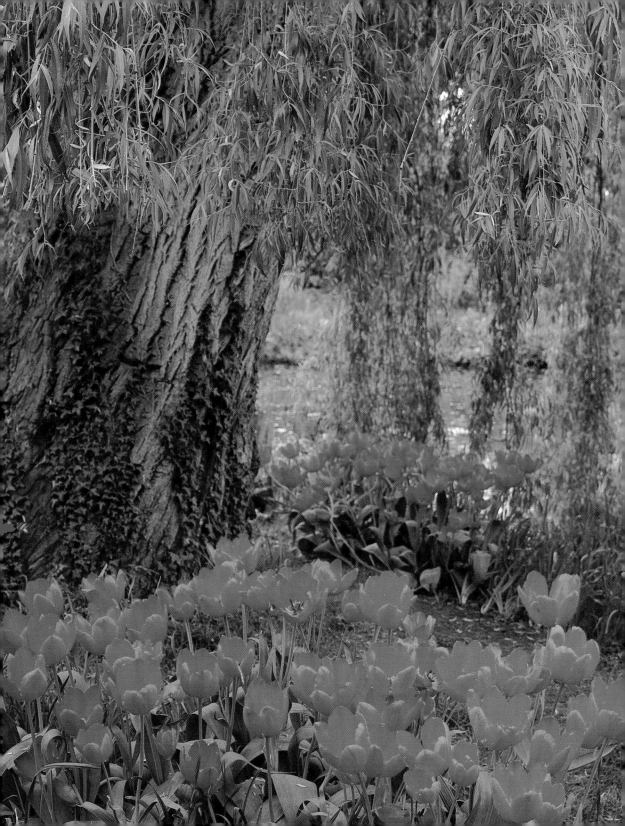

September

16

17

18

19

20

21

22

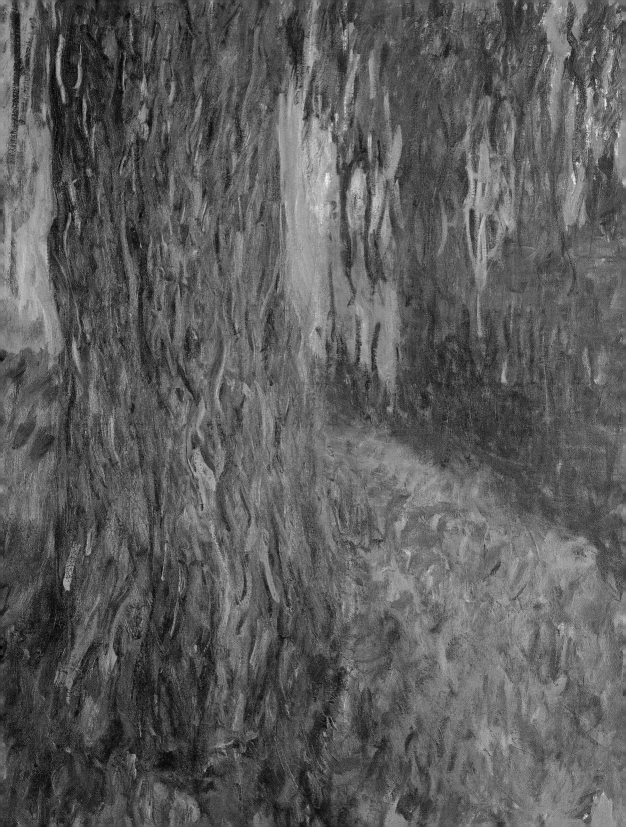

September

23

24

25

26

27

28

29

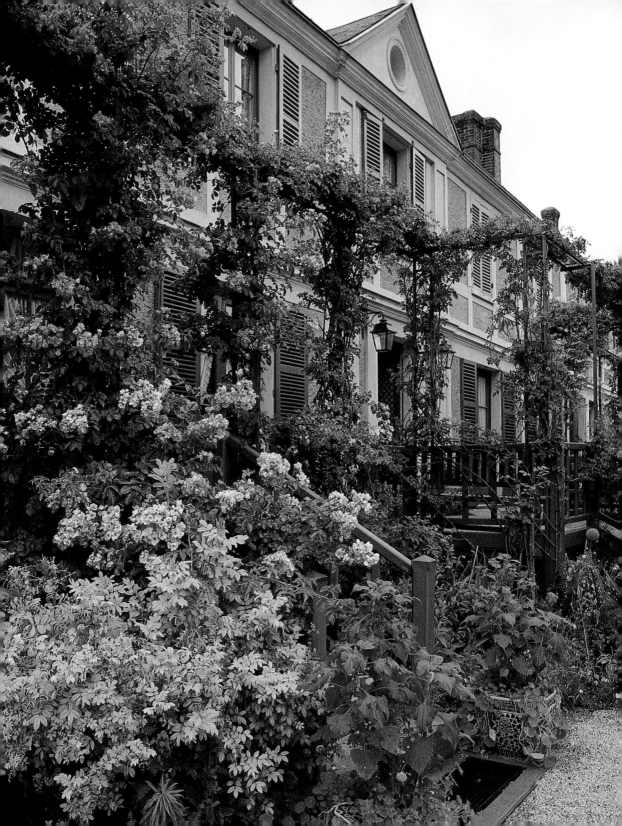

September-October

La Maison de L'Artiste à Argenteuil. The Art Institute of Chicago.

1

2

3

4

5

6

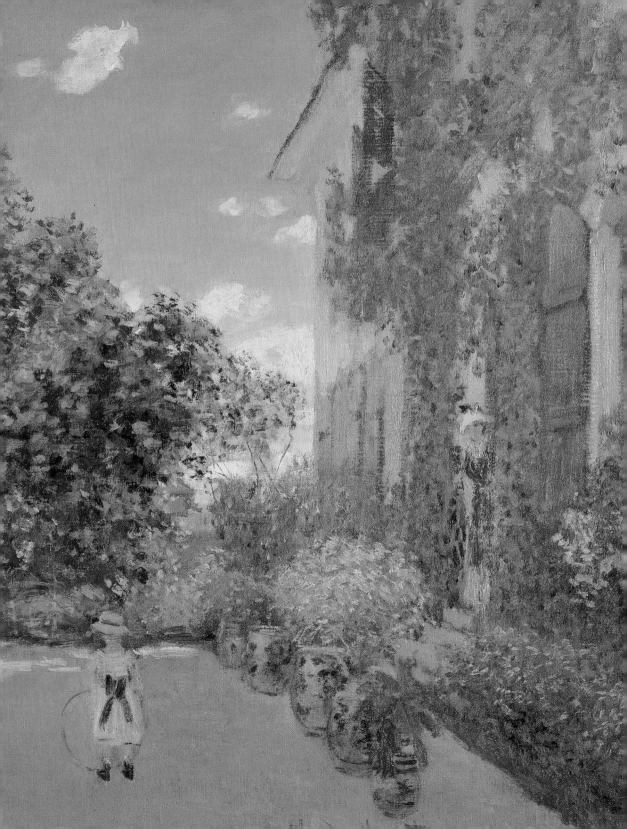

October

7

8

9

10

11

12

13

Poppies in the 'Clos Normand'.

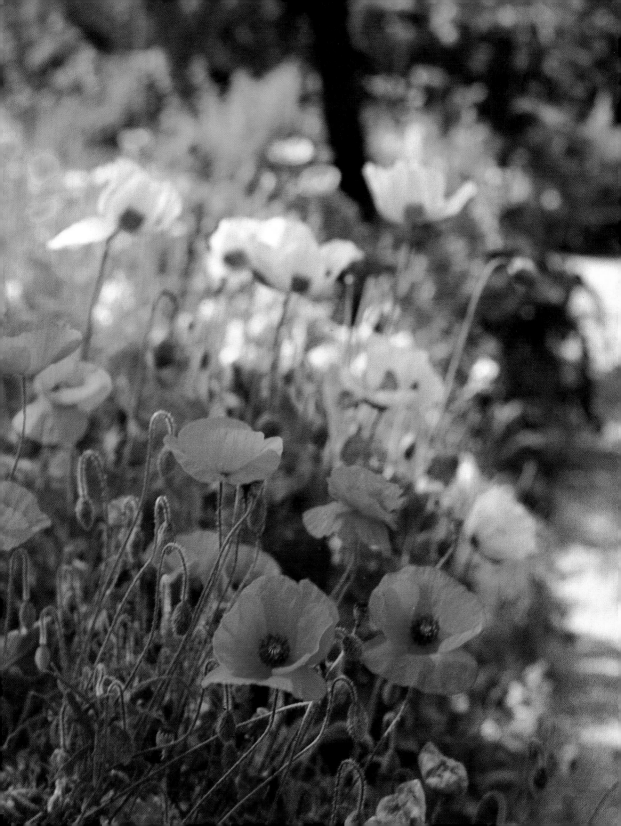

October

14

15

16

17

18

19

20

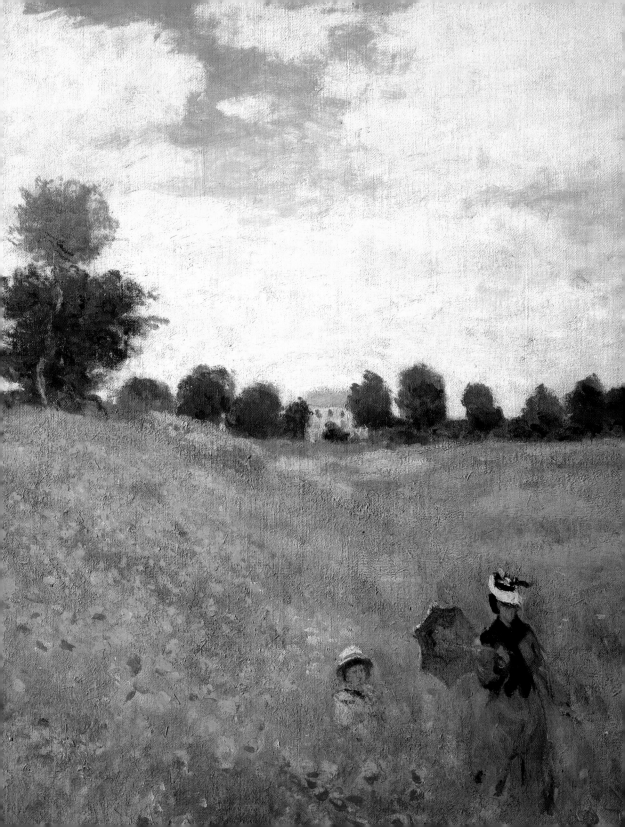

October

21

22

23

24

25

26

27

Roses in the 'Clos Normand'.

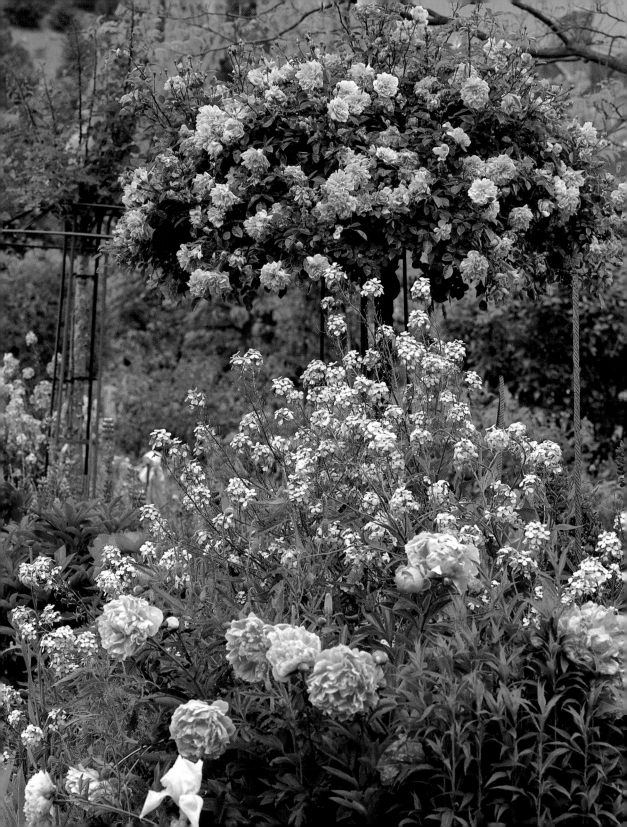

October-November

28

29

30

31

1

2

3

Les Roses. Le Musée
Marmottan.

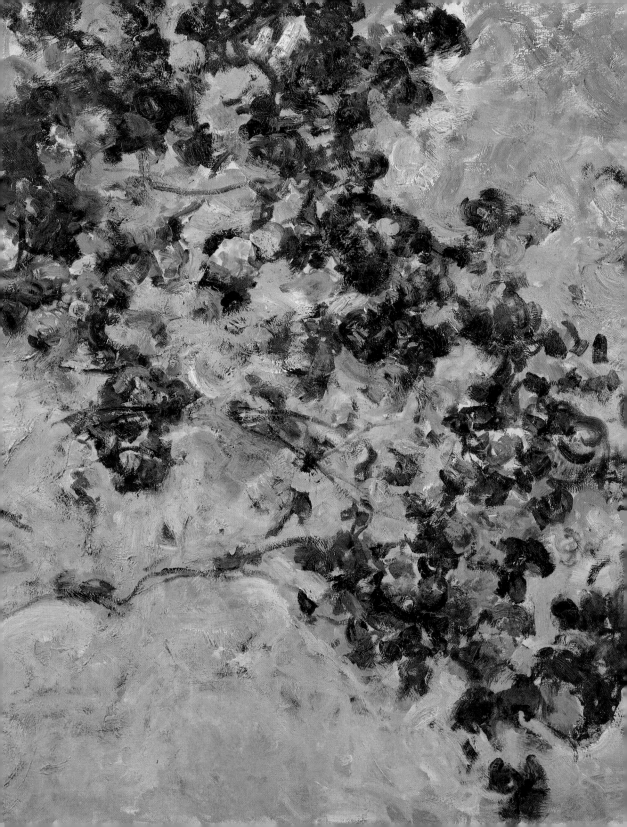

November

4

The water garden with irises.

5

6

7

8

9

10

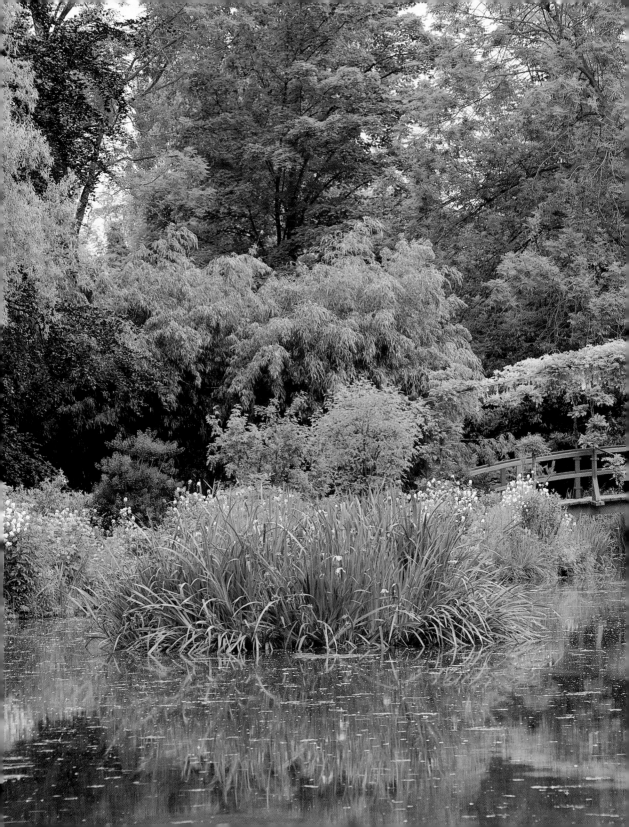

November

———————— 11 ————————

———————— 12 ————————

———————— 13 ————————

———————— 14 ————————

———————— 15 ————————

———————— 16 ————————

———————— 17 ————————

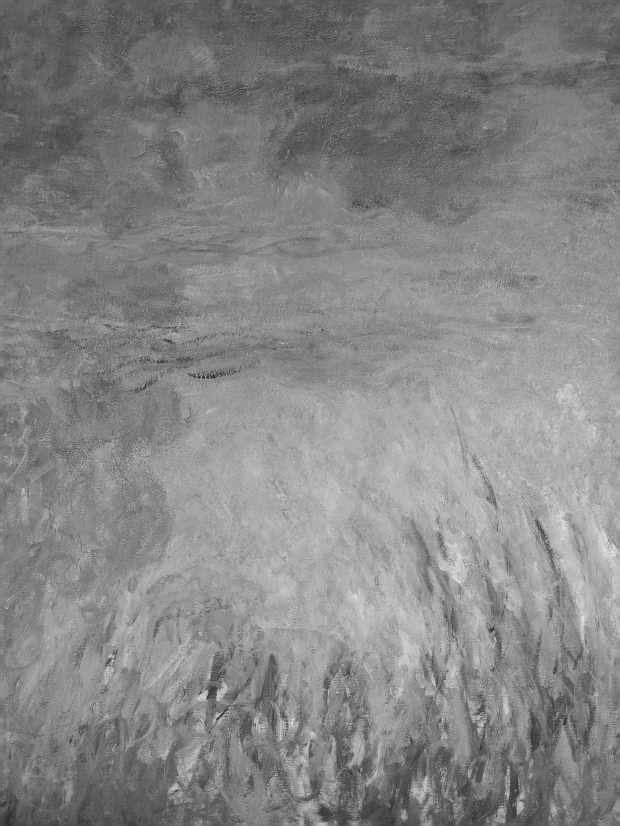

November

18 *Spring flowers.*

19

20

21

22

23

24

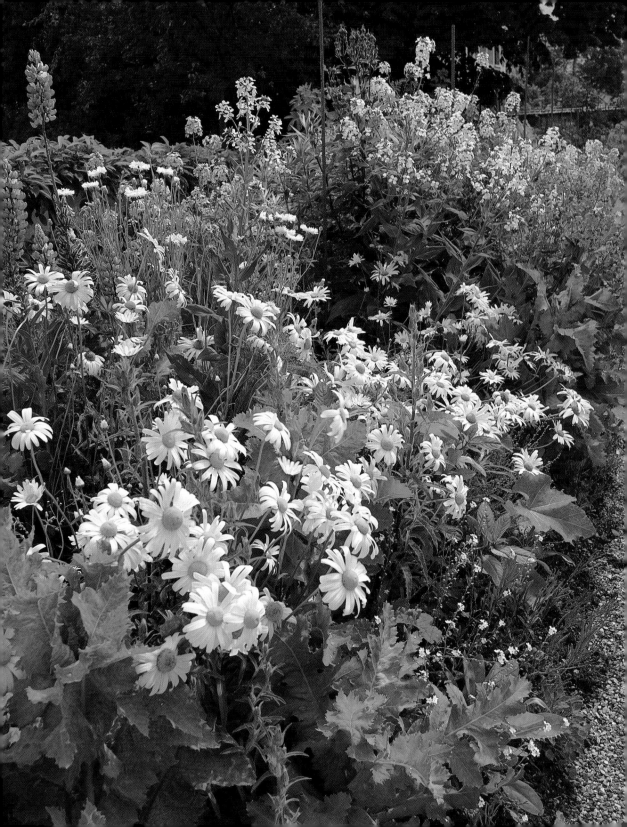

November-December

25

26

27

28

29

30

1

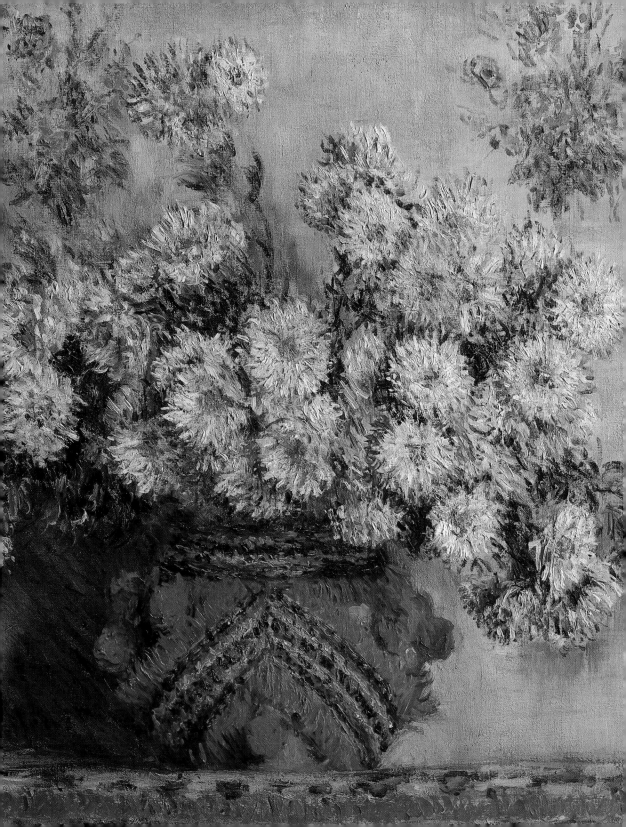

December

_____ 2 _____

_____ 3 _____

_____ 4 _____

_____ 5 _____

_____ 6 _____

_____ 7 _____

_____ 8 _____

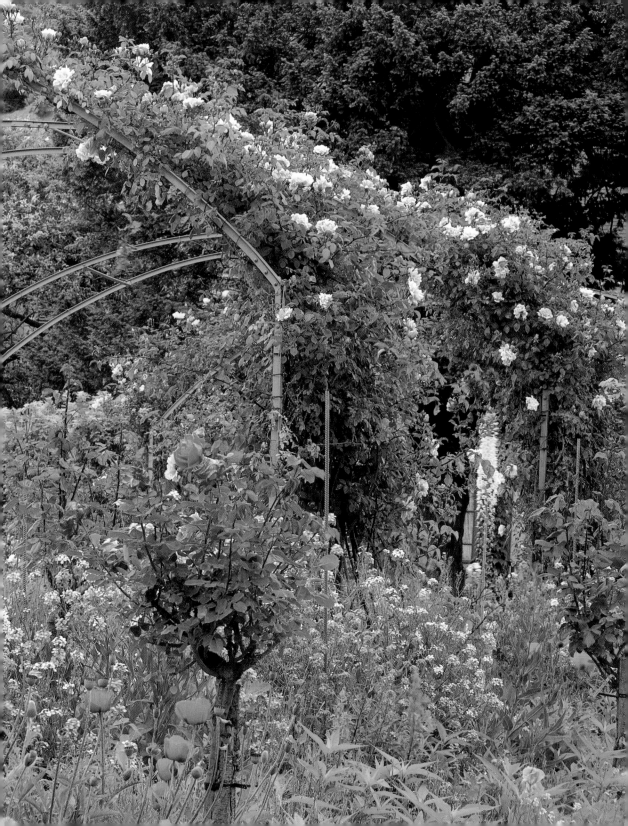

December

9

10

11

12

13

14

15

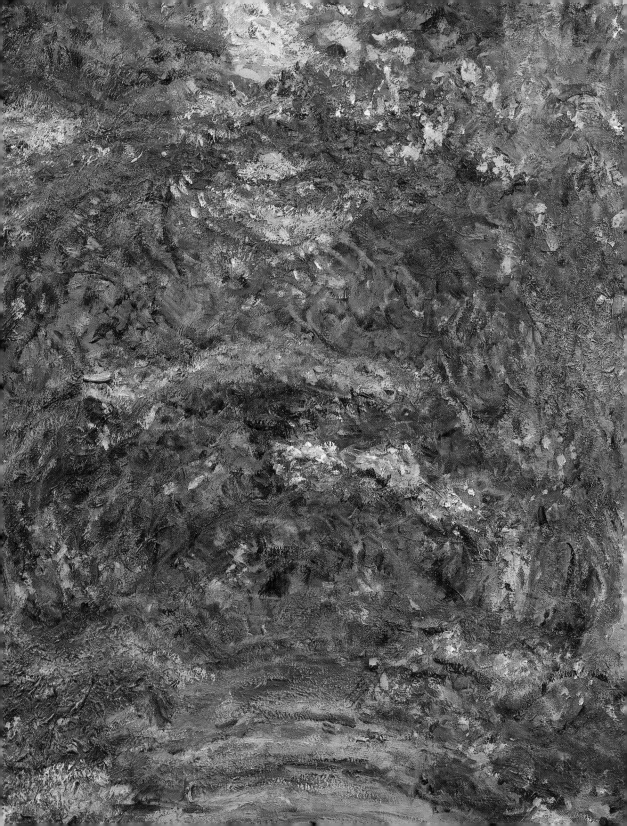

December

16

17

18

19

20

21

22

Spring border to the central pathway, Giverny.

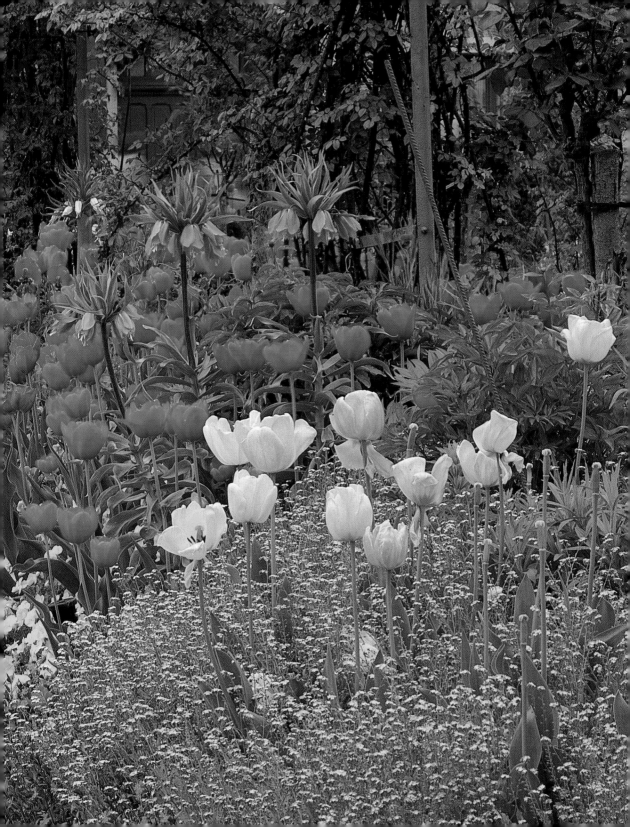

December

23

24

25

26

27

28

29